Three Times

Lisa Robinson

BookLeaf
Publishing

Three Times Seven © 2022 Lisa Robinson

All rights reserved.

Lisa Robinson asserts the moral right to be
identified as author of this work.

Presentation by *BookLeaf Publishing*

Web: www.bookleafpub.com

E-mail: info@bookleafpub.com

ISBN: 978-93-95088-81-7

First edition 2022

DEDICATION

In loving memory of my Dad, Keith Robinson.
I hope I've made you proud up there. I love and
miss you always.

And also with love for my heavenly 'Second
Mum' Mavis Gray.

ACKNOWLEDGEMENT

There aren't enough words in the world that would adequately express how grateful I am to my Mum for everything she has done for me. She is truly one in a million. Thank you Mum, I love you! I also want to thank my lovely brothers, Stuart and Simon, who've had to put up with me all this time, and for our default 70s humour setting!

Millions of love and thanks to my wonderful best friend, Kirsty, who 'gets it'. Loads of love to my dear friend David Lewis Gedge for everything! I also want to send love and thanks to: Amelia, Claire-a-Belle, Jane, Susan, Dawn, Keren, Liz, Kathy, Claire H, Rachel, Wendy, Jessica, Dean, Mark, Martin Ish, David, all my fabulous Gene friends, my 'Colbert ladies', Alex Lowe, Artiom, Petra, Magda, Erik (Rest in Peace my friend)
My heroes: John Peel, Oscar Wilde, JFK, Martin Rossiter, Steve Mason, Kev Miles, Matt James, Neil Hannon, Morrissey, Charlie Luxton, David Tennant, Ryan Gosling, and all the lovely people I've met along the way who have touched my life.

To SBD, I will love you for a thousand lifetimes.

To Stephen Tyrone Colbert, you are my guardian angel and I owe my life to you.

When Maxwell Met Epstein

If we stay here under the covers,
Will all of it go away?
If we keep it to ourselves,
Will we live to see another day?
If we pretend it never happened,
Will the world keep on turning?
If we carry on as normal,
Will the pain keep on burning?
If we force ourselves to smile,
Will they see through the lie?
If we promise not to tell a soul,
Will they continue to ask why?
If we choose to hide ourselves away,
Would they notice we are not there?
If we didn't ever speak again,
Would anyone even care?
You and your friends tried to break us,
But we're stronger than you'll ever know.
We are the glorious survivors,
And you underestimated every 'Jane Doe'.
You and your friends are truly evil,
And we hope you rot in hell.
We are the glorious survivors,

And we have a thousand stories to tell.

*For all the survivors of abuse: we hear you, we
believe you, we love you*

Sparks

I am certain
a fire like yours
will be a kiss of death.
You have danger
written all over
that instils
a raging thirst.
You make those
flames look enticing
and I feel
fireproof.
So let me dance
through the fire
with you,
'til we burn
down the roof.

Senses

My heart is so full of you,
I can no longer call it
my own.

My eyes are so entranced by you,
I can no longer see
the shore.

My arms are so in need of you,
I no longer can feel
the cold.

My lips are so drawn to you,
I can no longer taste
the air.

A Thousand Lifetimes

I would choose you in a
thousand lifetimes,
and still it wouldn't be enough.
I would go through a
thousand heartbreaks,
just to feel your love.

You have always found
your way to me,
and I have found
mine to you.
And so,
I am not worried.
Our hearts
know what to do.

So, for the next
thousand lifetimes,
remember to always
wait for me.
I am on my way
to find you.
And you will turn
and smile at me,
because your heart
always knew.

Déjà vu

I think I knew
there was something about you.
A feeling of recognition,
of trust,
and of love.
I think you understood me,
when nobody else could.
And so, I made
the decision,
to open my heart
to you.
I didn't know it
in that moment,
but it was
the sweetest thing
I'd ever do.

Sentinel

I would stop all the clocks
if I could have
one more minute
with you.
I would turn back all the tides
if I could walk
one more time
with you.
I would stop all the leaves from falling
if I could watch
one more sunset
with you.
I would stop my eyes from crying
if I could have
one more hug
with you.
But life must keep on moving
and you wouldn't want me
to stand still.
So these memories stay with me,
and when the time is right
to meet again,
we will.

100 Boxes

Boxes, and bags, and cases
are stacked against the wall.
I am just like Evita;
another suitcase in another hall.
My life is folded, and counted,
and moved from place to place.
Unpacked and re-positioned,
a fake smile upon my face.
I start my life over again
and hope this will be the last.
I pray things will be different
as I try to escape my past.
I long to be finally settled,
in a home I can call my own.
Instead of moving boxes,
to a life that's just on loan.

Tactile

Sometimes, all I want
is to be held.
For someone to stay
long enough to make me feel
safe.
To make me feel
loved,
wanted,
and needed.

Sometimes, all I need
is for you to take
my hand,
and never let go.
To make up for all
the times
when I could barely
hold on myself.

The Future Is Already Here

She will be
the one
who finishes
all your sentences,
who gets all your jokes,
and still laugh
every time
you tell them.
He will be
the one
who stays,
when life
urges him to go,
instead he'll
pick up your pieces,
and still think
you're perfect.
You will be
the one
whose heart
I will protect.
Whose dreams I will nurture,
and give us the love
we've both
been dreaming of.

Orange Roses

Perhaps our love
was too perfect,
like rose petals
in the wind;
beautiful,
but fragile.

Perhaps we shone
too brightly,
like fireflies
in the night;
illuminating,
but fleeting.

Perhaps we burned
too fiercely,
like bonfires
on the beach;
glowing,
but dying.

Icebergs Melting

The version you see of me,
was not forged overnight.
I did not become who I am
from one moment of madness.
This version here before you,
was sculpted by raw experience,
chipped away by self-doubt,
and honed by years of pain.
Depression and anxiety
drew forth oceans of tears,
that caused scars deep and wide.
Abuse, and rejection
formed icebergs insurmountable,
and dangerous, insecure peaks.
And yet, I choose not to let
it define who I am.
This version is not my sum total;
'for out of great darkness,
comes a shining light,
and all my icebergs start melting,
when you hold me tight.

The Face That She Keeps In A Jar By The Door

Which face would you like me
to wear today?
Which character would you like me
to be this week?
Tell me how I can mould myself
to make you feel more comfortable,
while the real me slowly
dies inside.
Show me everything I'm doing wrong,
and demand I be more like you.
I can be anything you want
me to be.
The only person I'm not 'allowed' to be
is myself.
The real me is not acceptable,
The real me is not 'normal.'
The real me cannot be an individual,
creative, passionate, or free.
"The real you is weird! You need to
be more like me!"
But I would never want to be viewed
as 'normal,'
if it means I act
like you.

The real me is beautiful, gentle,
and kind.
Empathetic, funny, with a
crazily active mind.
So, from today, I will only wear
my own true face.
I can no longer pretend
to be
someone I'm not.
It hurts me too much to
hide my true colours away.
Those who hate me will leave,
but the ones who matter,
and who love me,
will accept me and want to stay.

The Architect

You surveyed the room
until your eyes met mine.
You gave me a smile
that was perfect by design.
You spoke eloquently
about 'Building the Dream.'
And I listened intently
about brick, and walls, and beam.
You came to talk to me
and I felt your electricity.
You're a classic work of art;
a vision of perfect symmetry.
You made me feel at home
with your (eco) friendly talk.
You glanced at my chimney breast
as you spoke of screws and caulk.
You engineered our conversation
with balance, grace, and style.
You made me Queen of your Skyscraper
we two flying high for a while.
We made a plan to meet
but it was just a façade .
The landscape was too rocky,
our dwelling a 'House of card'.
I wanted something sustainable,

a structure of love and light.
But all I got was 'Brutalism',
my heart breaking in the night.
You are my graceful Architect
and I your hand-drawn plan.
Your beautiful construction
is my (building the) dream man!

For CRL with 'tenacious' love

Not Enough Spoons In The World

I don't have the energy
to go outside today.
I don't have the energy
to work, rest, or even play.
I need to sit quietly
with space and time to think.
I need to sit quietly
with cups of tea to drink.
I can't socialise with people
if they require too much of me.
I can't socialise with people
if lights are too bright to see.
I don't have the mental bandwidth
to take on another task.
I don't have the mental bandwidth
so please don't even ask.
I need some time alone
so I can feel 'normal' again.
I need some time alone
so I can rid myself of pain.
I don't have enough 'spoons'
to try and be myself.
I don't have enough 'spoons'
I must conserve my health.

I need to hide away from it all
just for a day or two.
I need to hide away from it all
it's just something I have to do.
There aren't enough spoons in the world
for everything I want to say.
There aren't enough spoons in the world
when exhaustion gets in the way.
So, please be gentle with me
as I go and retreat for a while.
And please be patient with me,
I promise to return with a smile.

00:07

When sleep won't come
and night stretches on forever.
When thoughts won't stop
and conversations come back to
haunt me,
It's always you on my mind;
a permanent fixture to
taunt me.

I sometimes feel
I will never be free
of these demons
who take devilish joy
in twisting the knife,
and reminding me of
how much I've lost,
and will never have again.

The Dreamers

We built a future,
that I'll never get to live.

We mapped a course,
that my ships will never sail.

We planned a home,
that I'll never get to visit.

We wrote a story,
that I'll never get to read.

We dreamed a dream,
that I'll never get to see.

We made so many memories
that I can't simply forget.

Dreams are all I have now
in a heart with rooms to let.

Locked Rooms

There are locked rooms inside me
where I have lost the key,
there are things inside these rooms
I don't want them to see.

There are locked rooms inside me
full of cobwebs and of dust,
where my heart has been left out
to corrode and to rust.

There are locked rooms inside me
that don't see the light of day,
rooms that stay dark and hidden,
it just seems safer that way.

There are locked rooms inside me
that perhaps I would show to you,
maybe it's time to let in the light,
and for us both to enjoy the view.

Seafolly

If you are the sun,
then I am the sky.

If you are the moon,
then I am the stars.

If you are the sea,
then I am the sand.

If you are the clouds,
then I am the rain.

Different, yet intertwined.
Impossible to exist without
the other.
With no true beginning
and no end,
like the tide that
eternally kisses the shore.

Black Cloud

You have never been welcome
in this house,
but you entered
all the same.

You have never been wanted
on this journey,
but you always
tagged along.

You were never asked
for your opinion,
but you gave it
nevertheless.

You were never invited
to my party,
but you turned up
unannounced.

You have always been
close behind me,
waiting and watching,
hoping to catch me
off guard.

You look for an opportunity
to climb in through
my windows,
and make yourself
at home.

There is no space here
for you,
and I kindly ask
you to leave.
Black Cloud you are
not welcome;
I'm ready for
sunnier skies.

Jigsaws

You left not because
 you stopped loving her,
but because you thought
 she wanted more.
When all she ever needed,
 was every piece
 of you.

Gravitational Pull

Souls have a habit
of gravitating back
to the ones who
make them feel
they are home.
The Universe is pushing
your soul closer
to mine,
and I cannot argue
with the laws of gravity.
My heart is
your home forever,
until the stars
all fade away
and we become
stardust.